TITLE: *Film in five seconds*

OVER 150 GREAT MOVIE MOMENTS – IN MOMENTS!

BY: Matteo Civaschi

★ H-57®

Gianmarco Milesi

PUBLISHER: Quercus

MOVIES: 150

THIS **BOOK** IS **DEDICATED** TO **PIETRO** NADIA **DAVIDE** MIMMA MASSIMO **FEDERICO**

Matteo Civaschi - ★H-57® - Gianmarco Milesi

FILM IN FIVE SECONDS

OVER 150 GREAT MOVIE MOMENTS – IN MOMENTS!

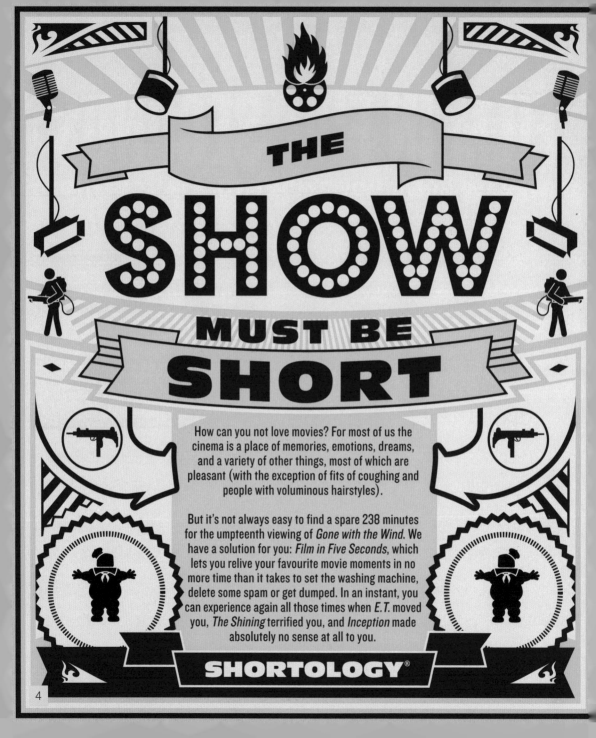

THE SHOW

MUST BE SHORT

How can you not love movies? For most of us the cinema is a place of memories, emotions, dreams, and a variety of other things, most of which are pleasant (with the exception of fits of coughing and people with voluminous hairstyles).

But it's not always easy to find a spare 238 minutes for the umpteenth viewing of *Gone with the Wind*. We have a solution for you: *Film in Five Seconds*, which lets you relive your favourite movie moments in no more time than it takes to set the washing machine, delete some spam or get dumped. In an instant, you can experience again all those times when *E.T.* moved you, *The Shining* terrified you, and *Inception* made absolutely no sense at all to you.

SHORTOLOGY®

It is a simple system, one we call 'Shortology' (and one which has already given rise to *Life in Five Seconds*, this book's predecessor,) for lack of a better term. Basically, it involves removing all the unnecessary bits, to leave you with a few graphical icons.

We hope you will find your favourite films in this book. Of course, if your favourite film is one in which the protagonist is a performing squid or one that tells a heartbreaking story of love between decathletes, you may not find what you're looking for. But for everyone else, your favourite movies are probably in here, even if you fall into such bizarre demographics as 'men who like *Pretty Woman*' or 'women who do not like *Pretty Woman*'.

The book is like a quiz, and the game is to guess the film from the graphics. Come on, it's not that hard: how many movies have a six-legged horse with a plug-in tail, or a woman who uses an umbrella to fly? If you like movies, you'll be able to get most of them, even without looking at the answers at the back of the book. So, enjoy the movies, but be quick about it.

This book is enhanced with exciting new technology, allowing you to unlock ⊙ animations from images in the book using most web-enabled smartphones or tablets. Simply download and open the free QuercusEye app, and look through the book for pictures with the QuercusEye icon. Hover the camera above the image so that the picture fits the screen and watch it come to life.

Go to **www.quercuseye.com** for more details

5

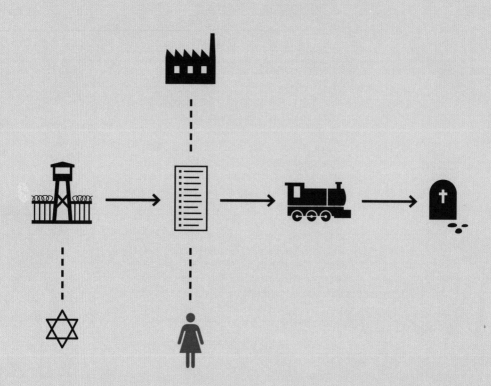

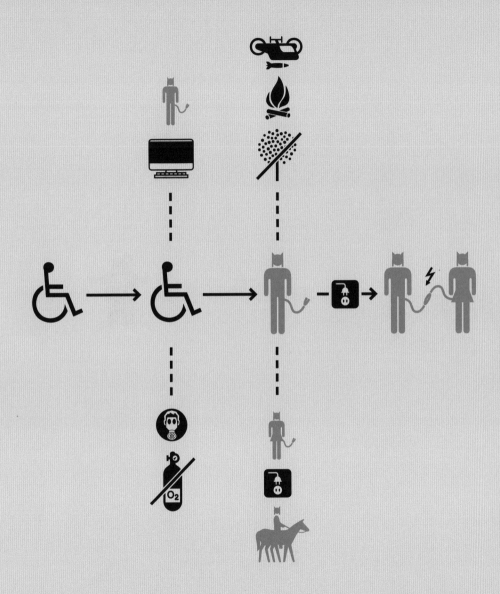

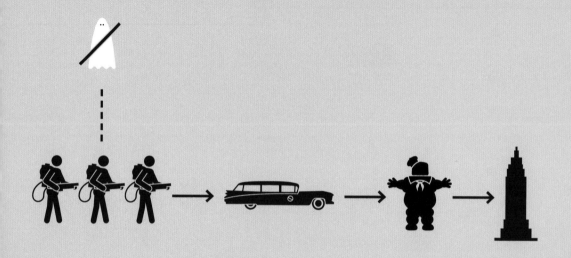

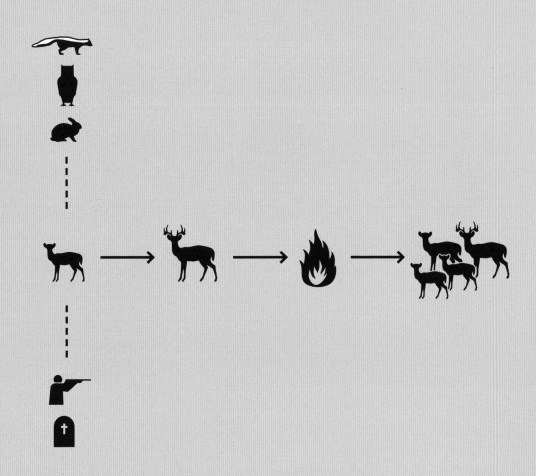

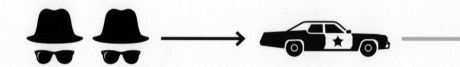

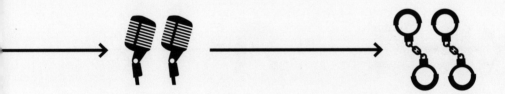

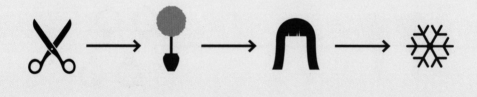

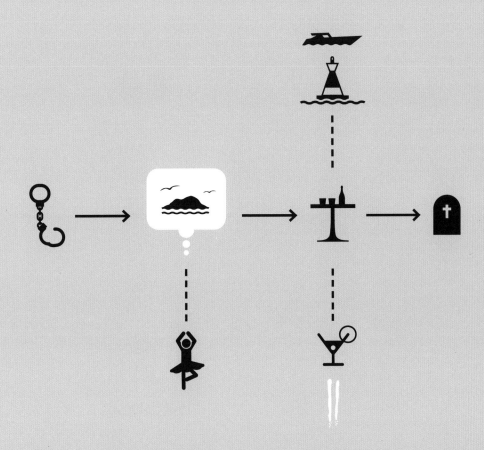

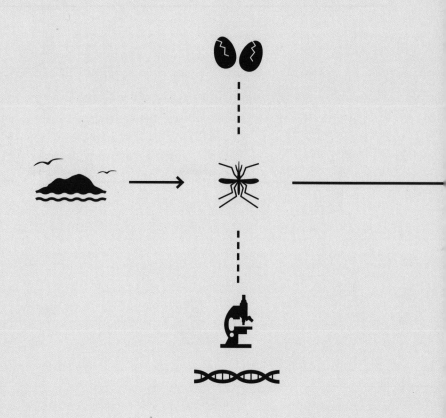

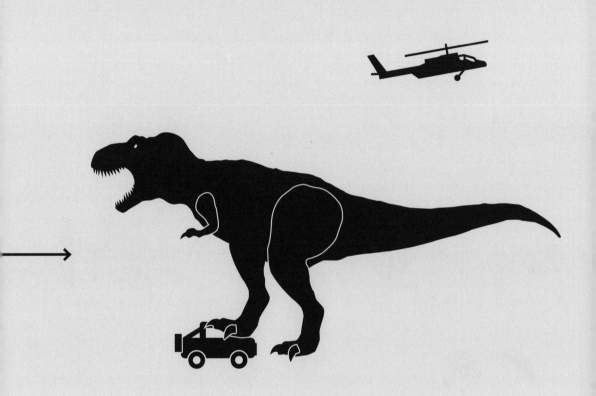

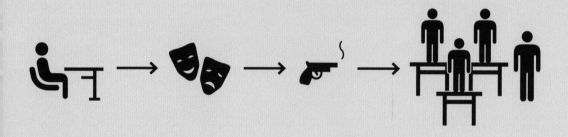

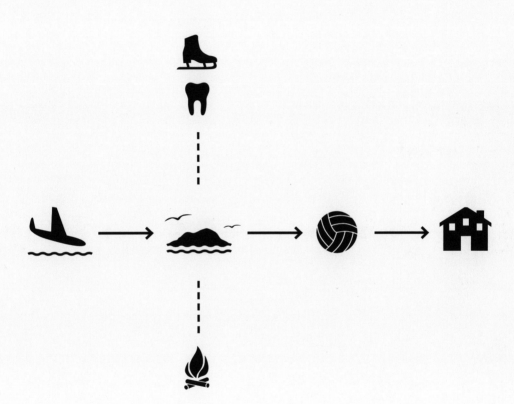

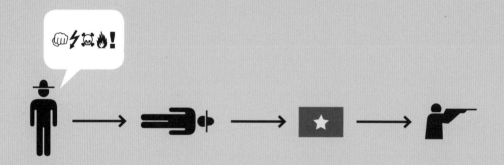

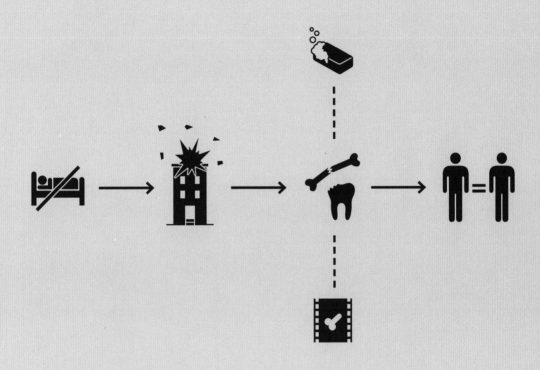

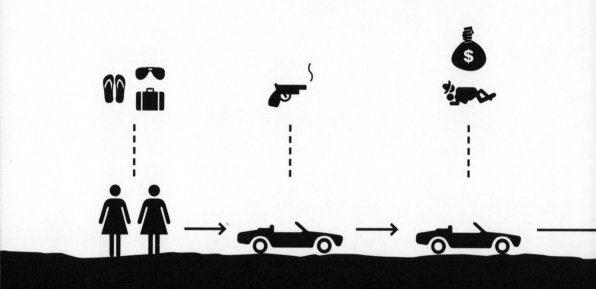

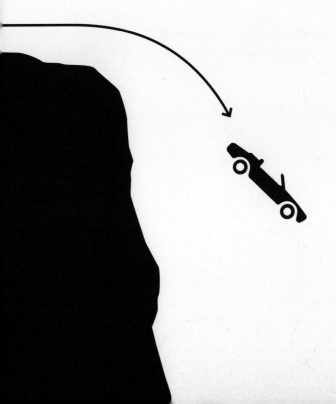

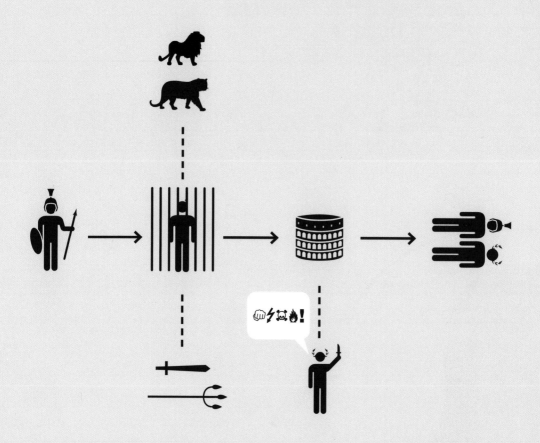

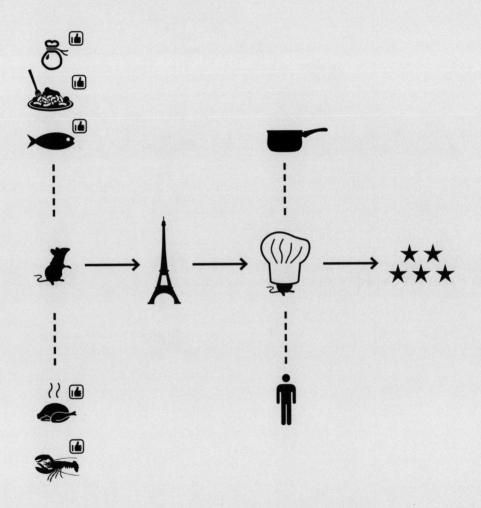

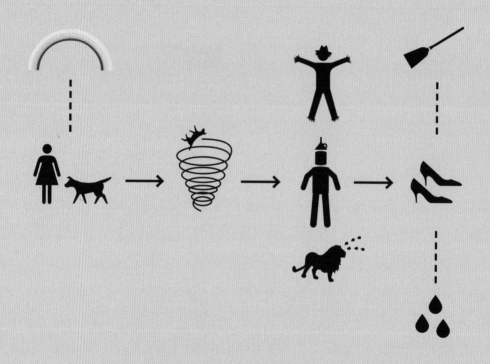

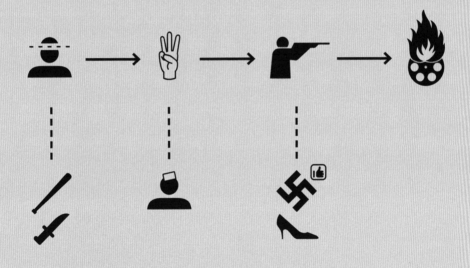

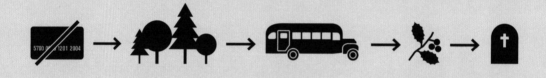

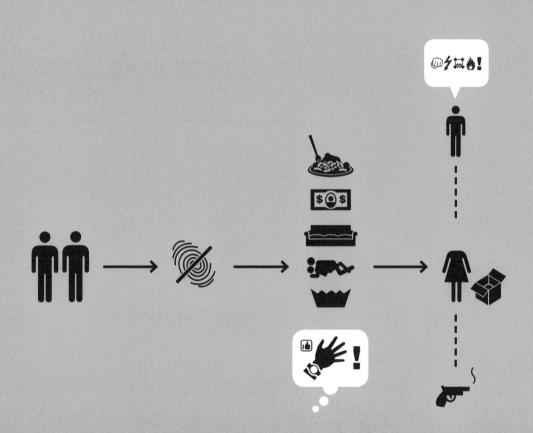

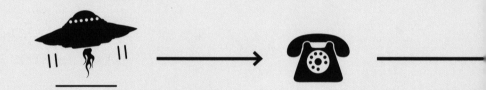

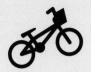

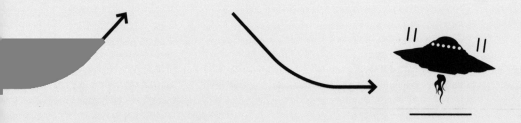

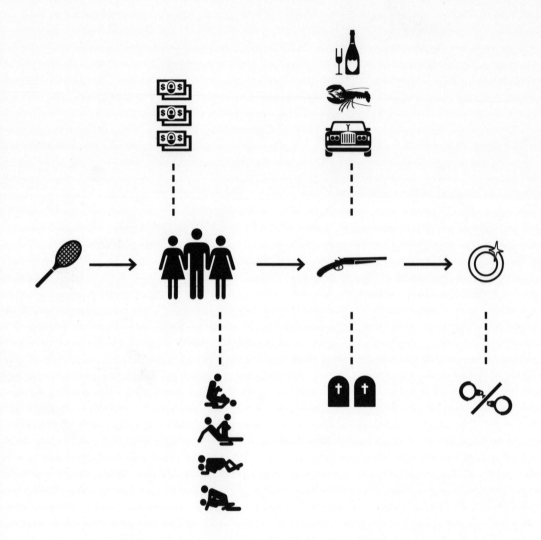

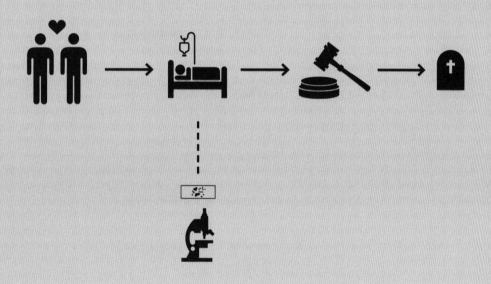

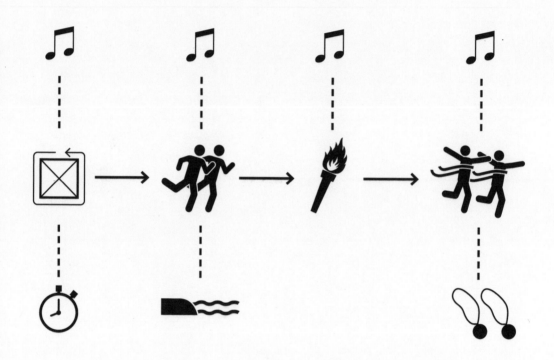

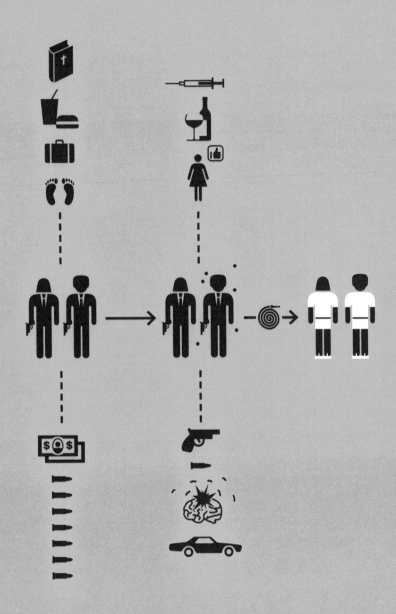

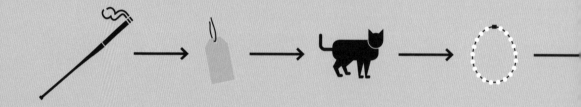

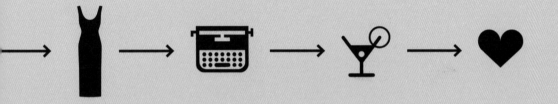

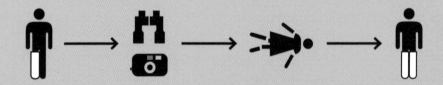

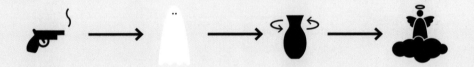

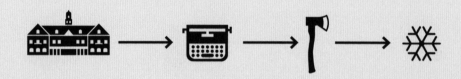

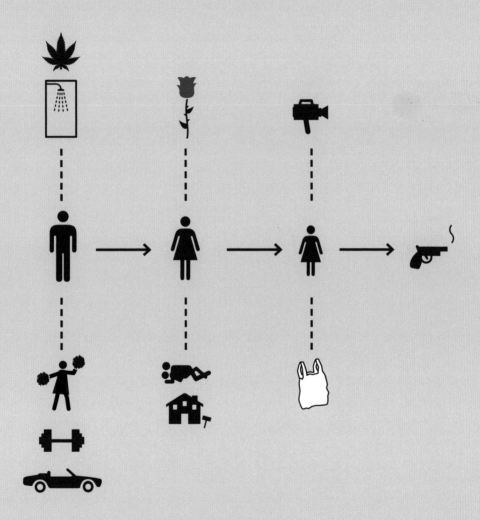

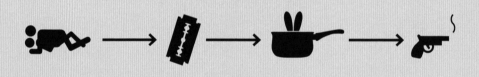

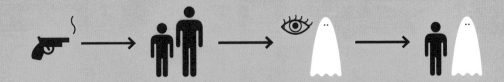

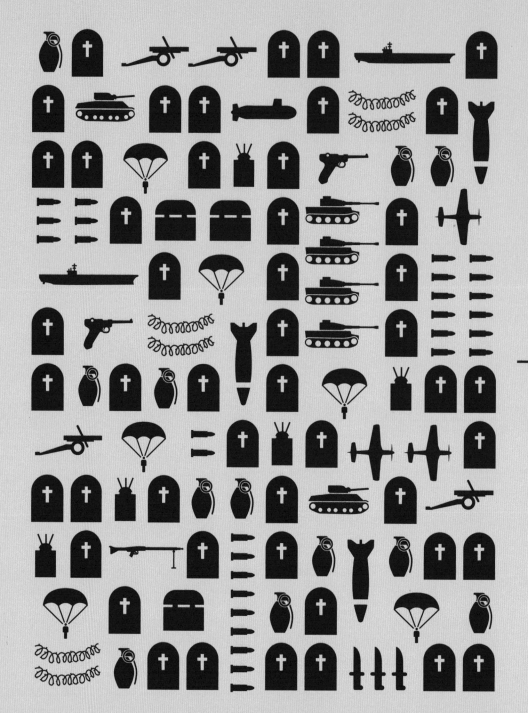

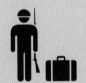

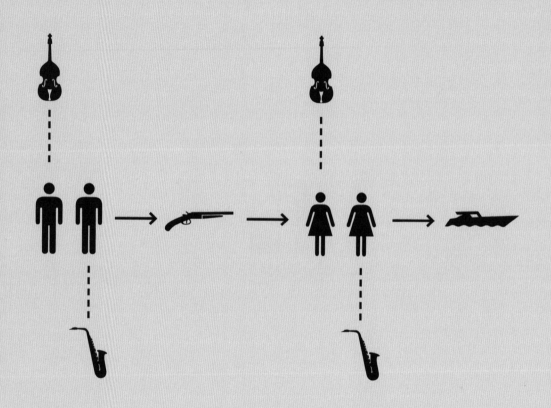

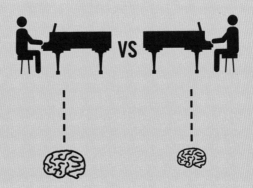

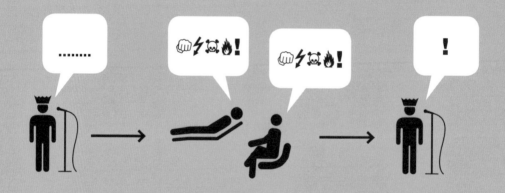

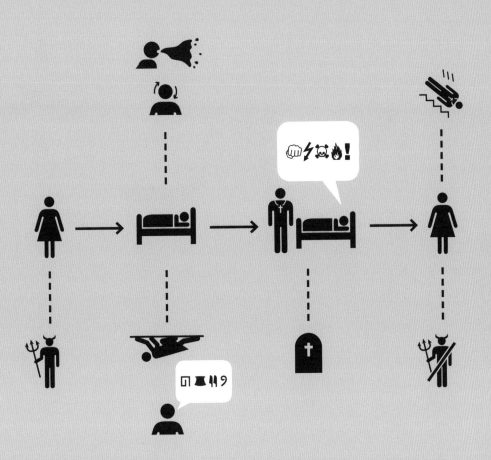

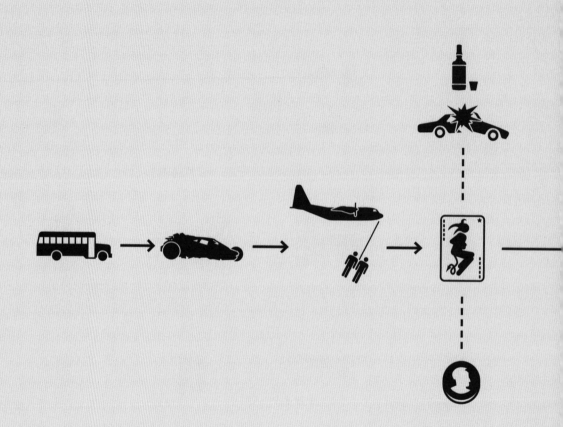

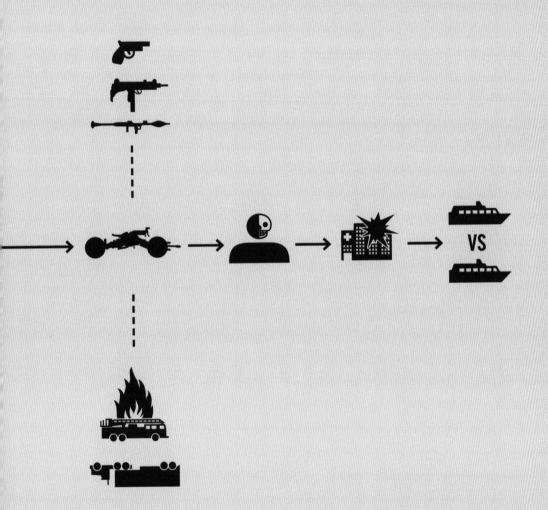

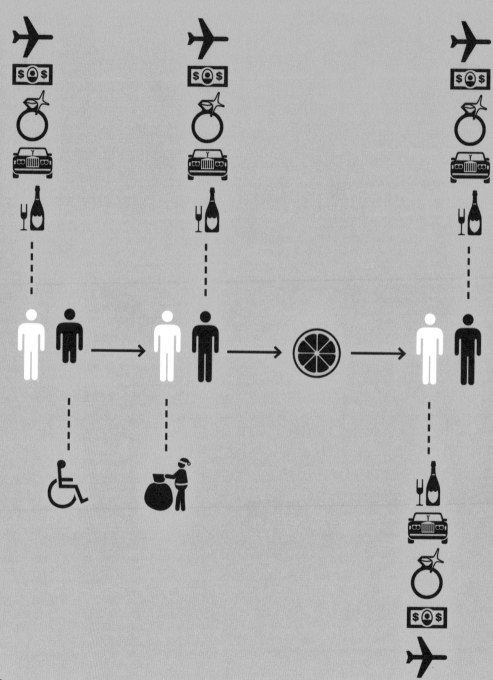

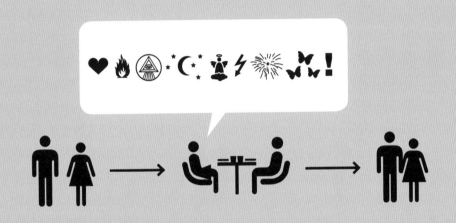

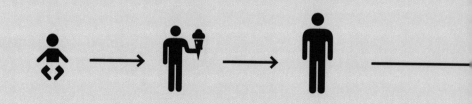

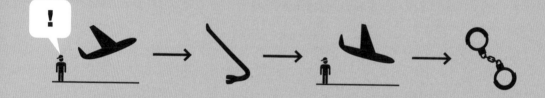

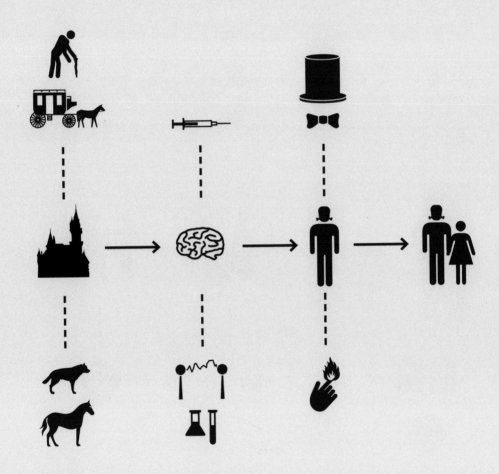

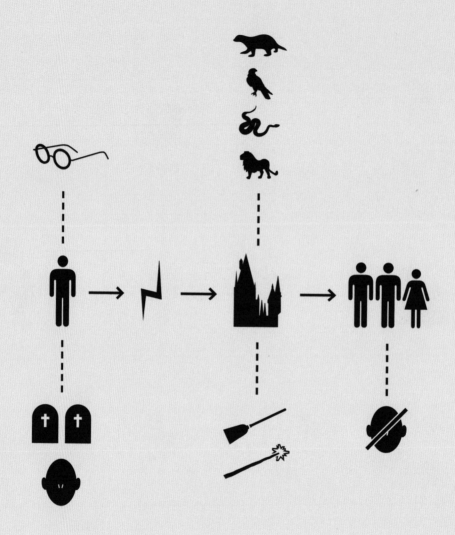

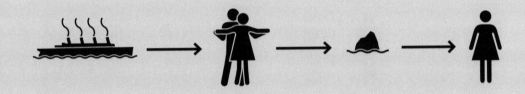

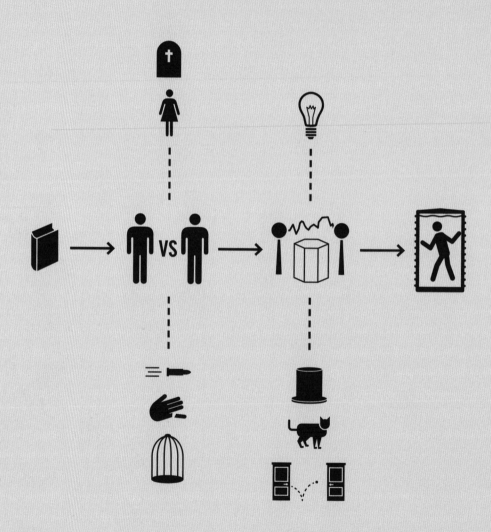

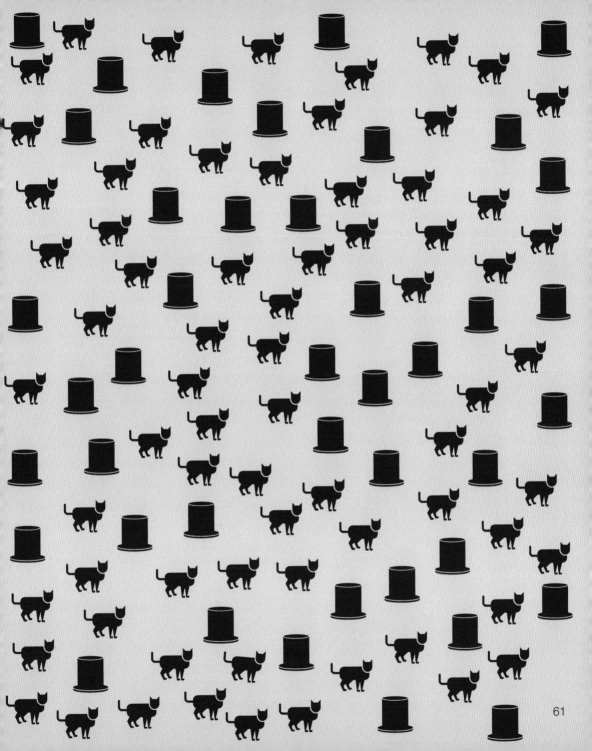

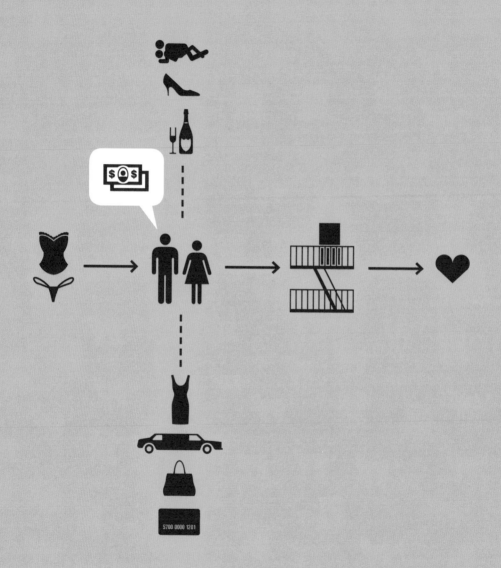

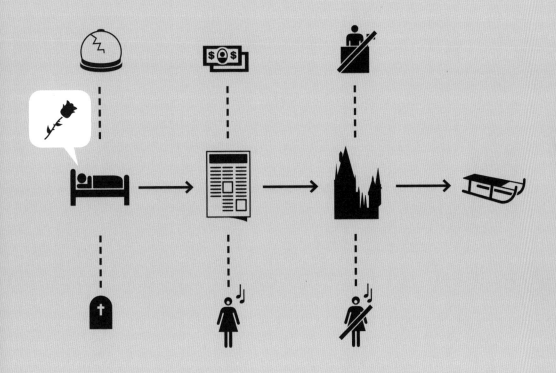

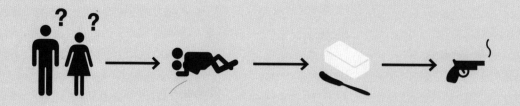

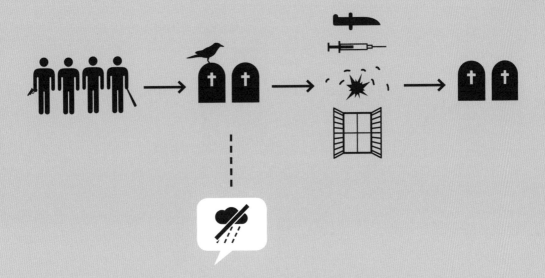

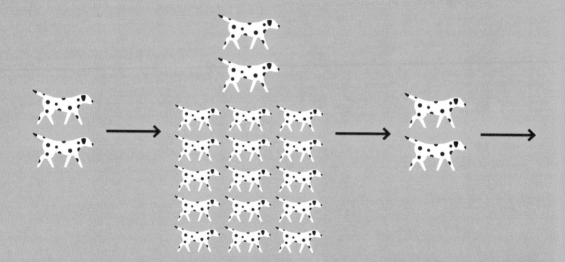

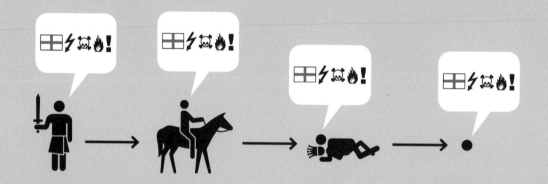

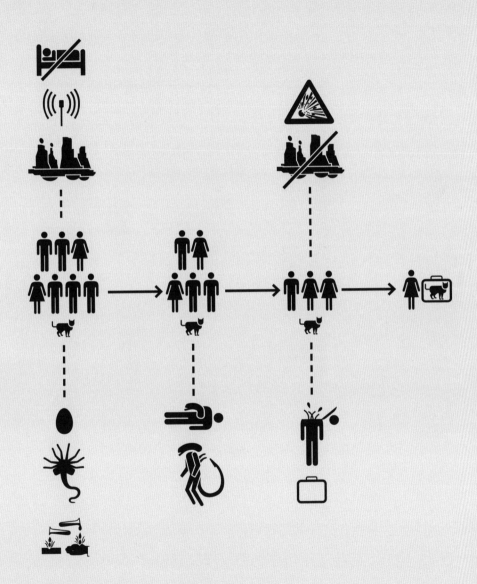

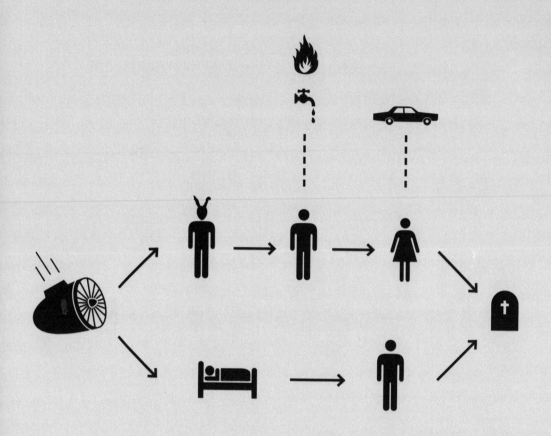

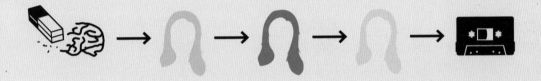

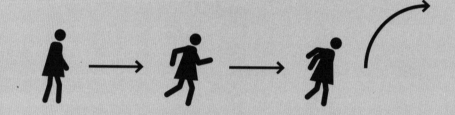

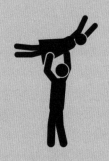

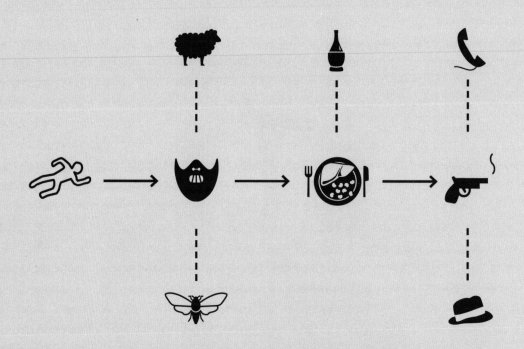

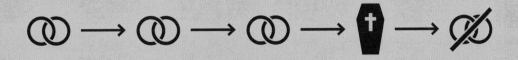

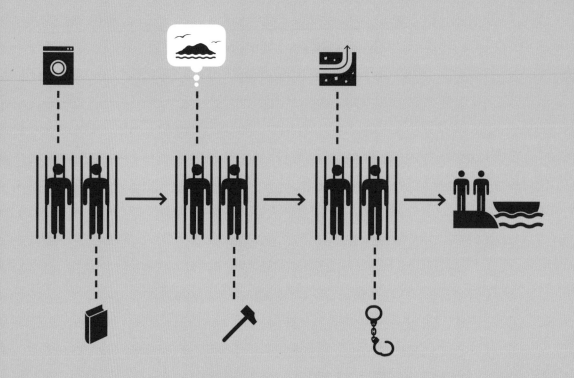

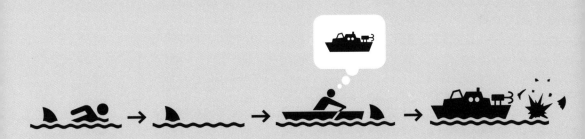

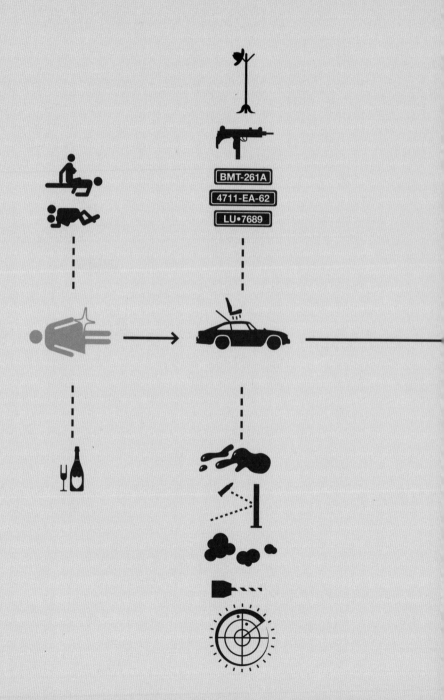

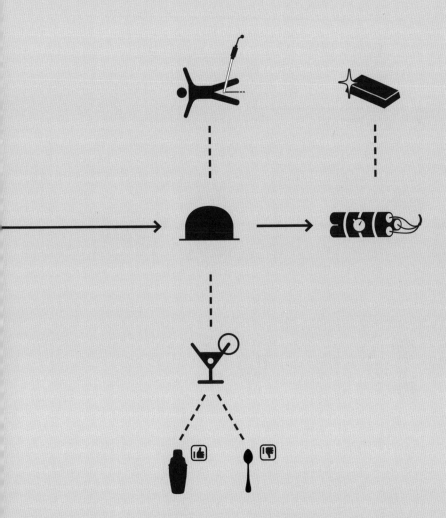

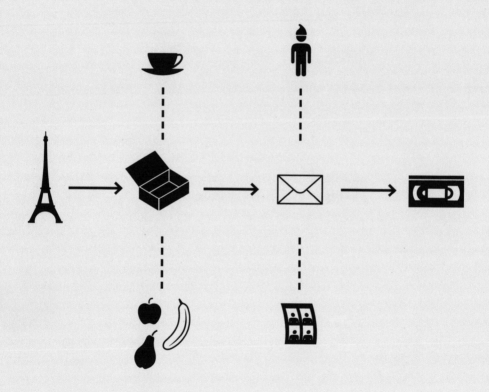

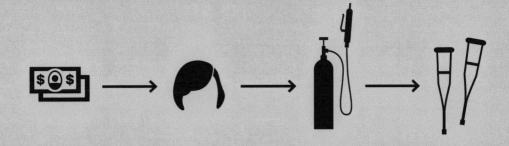

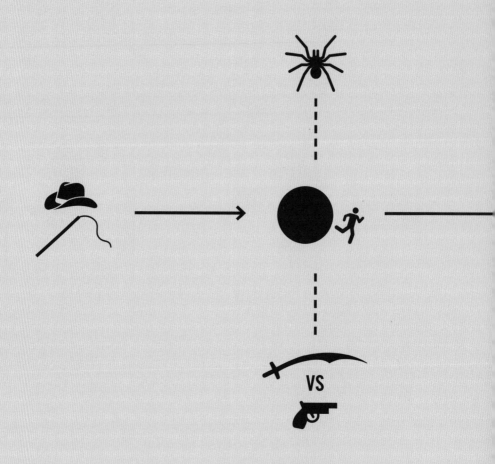

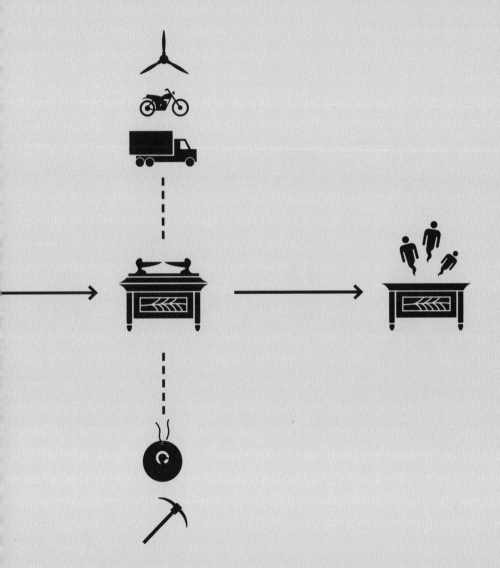

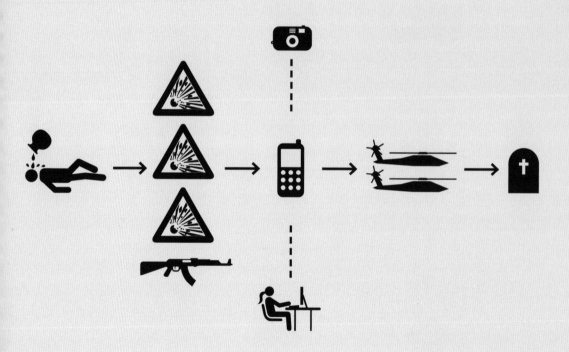

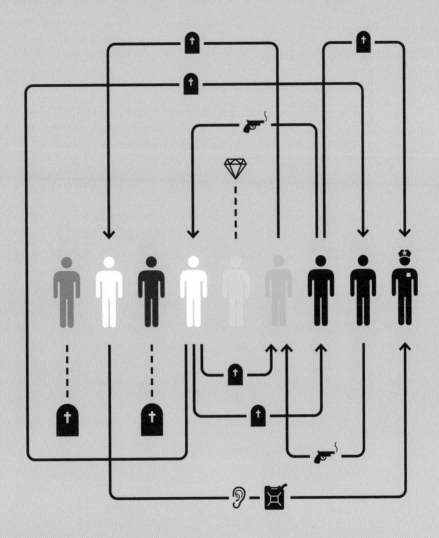

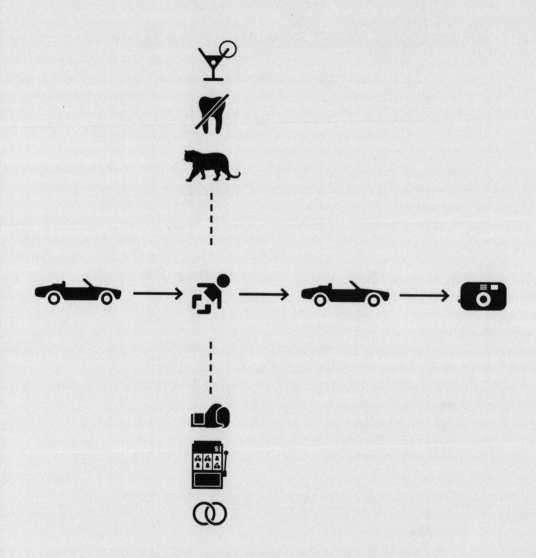

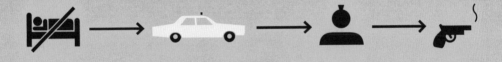

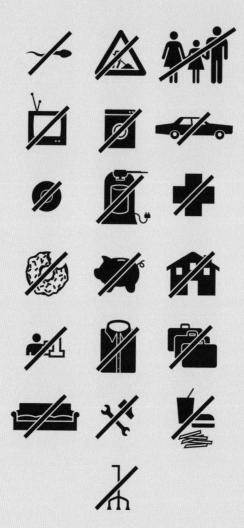

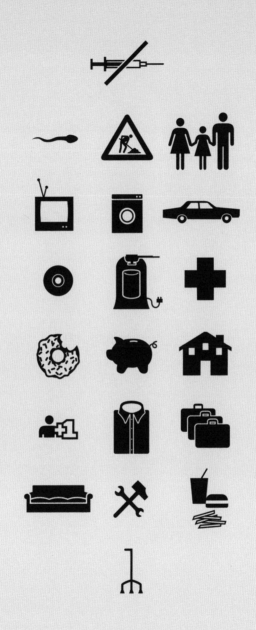

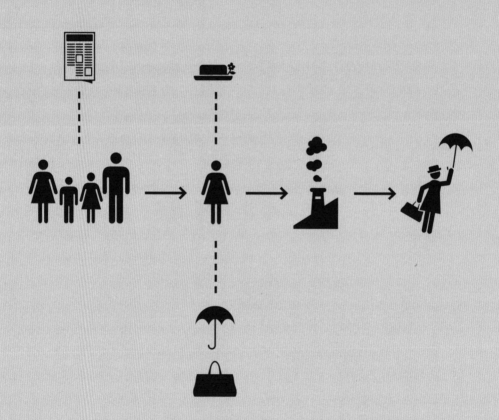

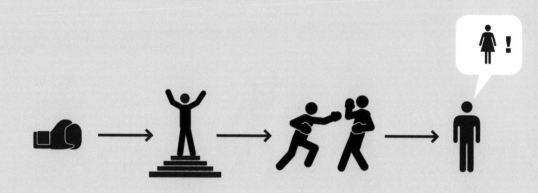

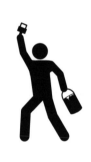

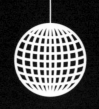

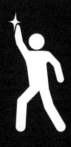

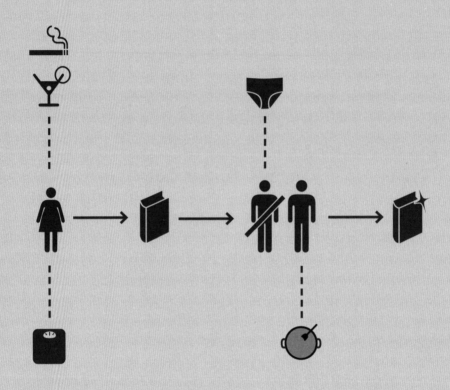

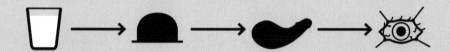

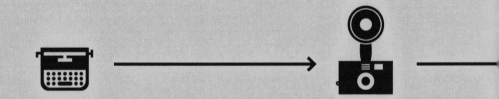

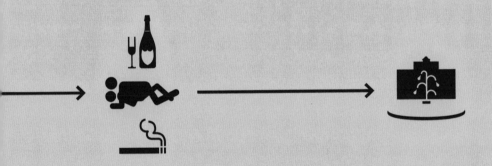

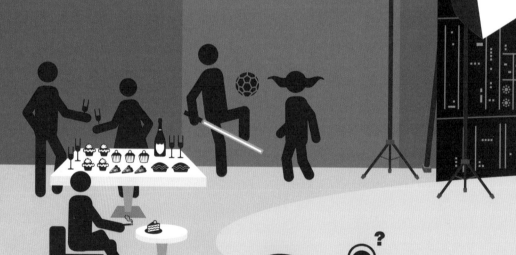

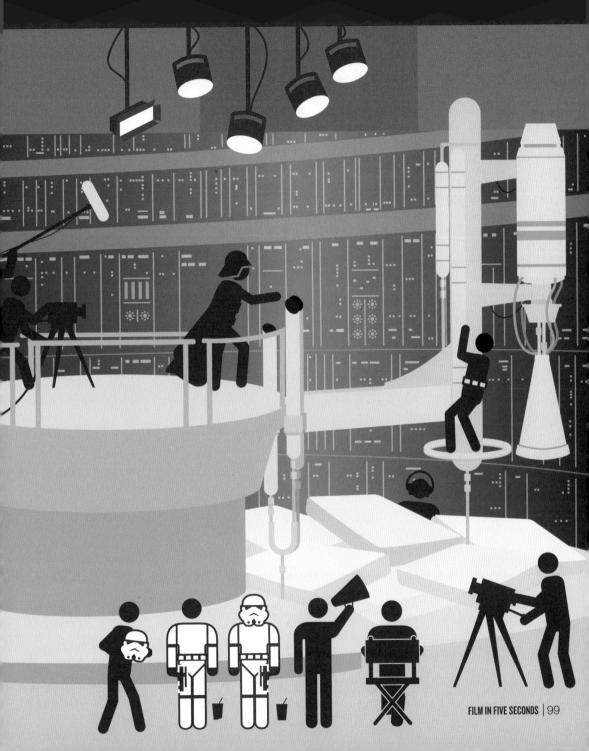

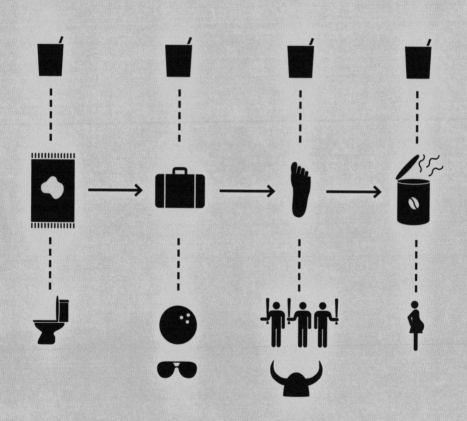

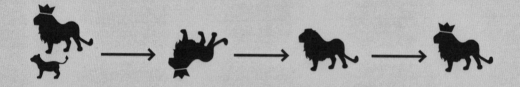

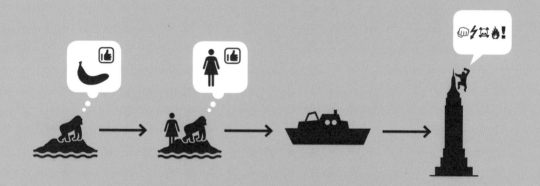

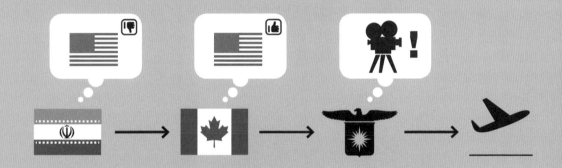

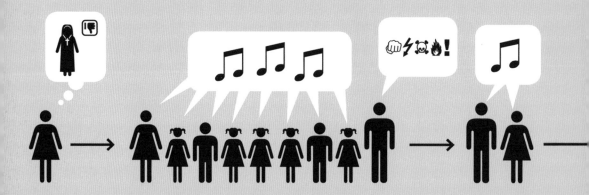

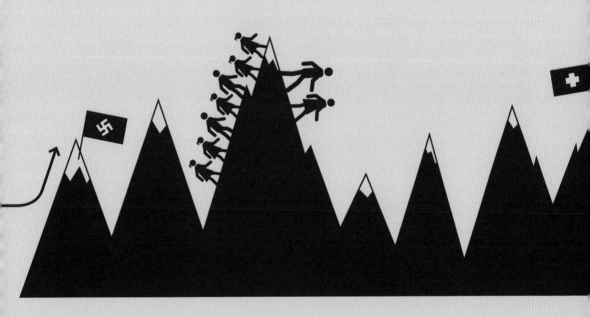

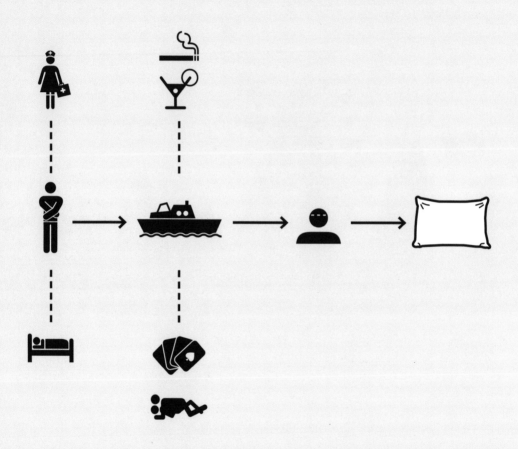

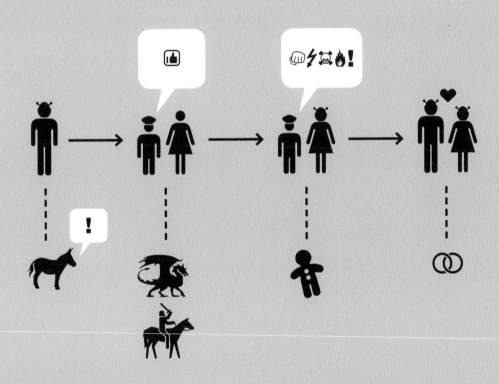

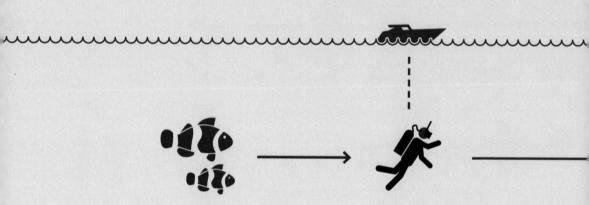

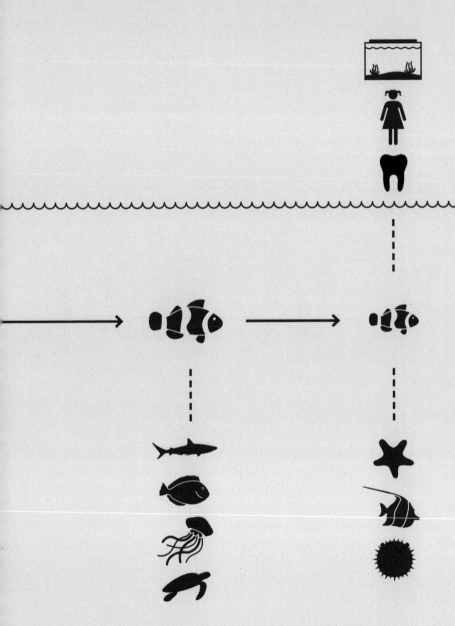

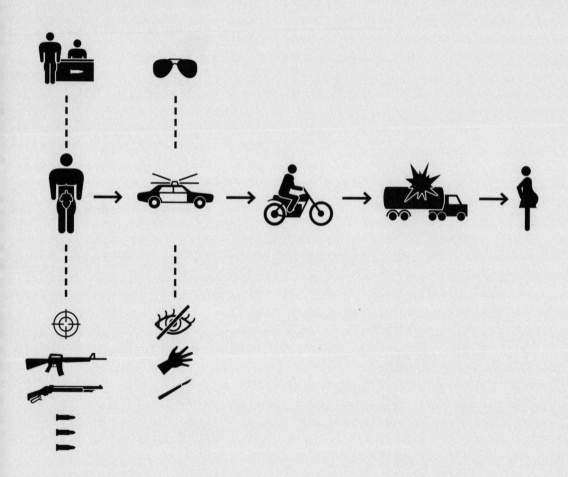

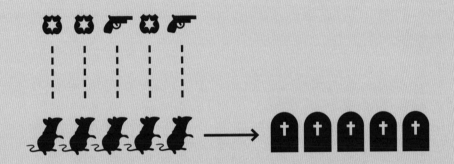

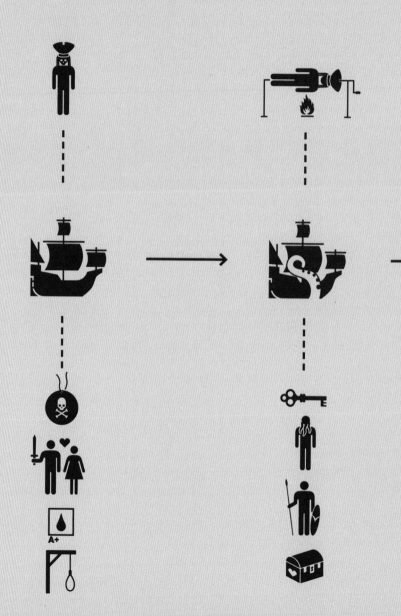

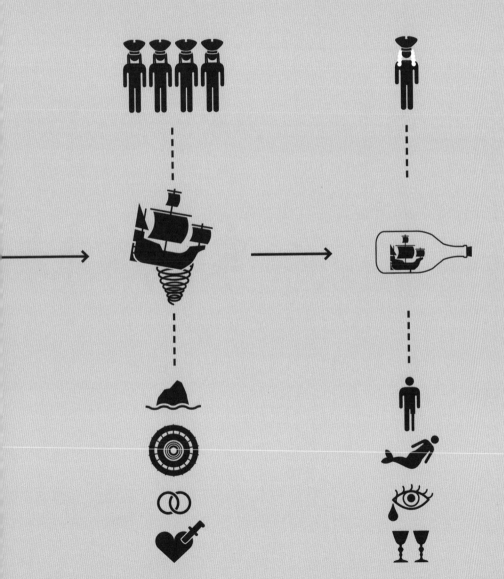

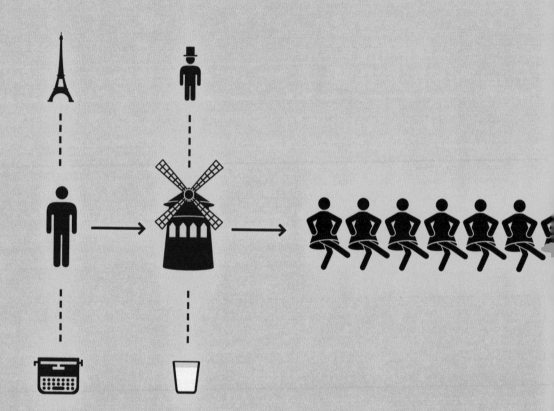

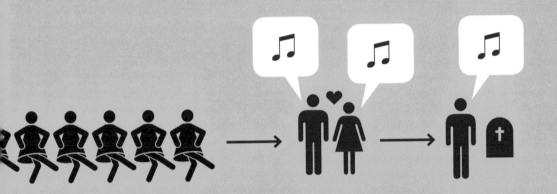

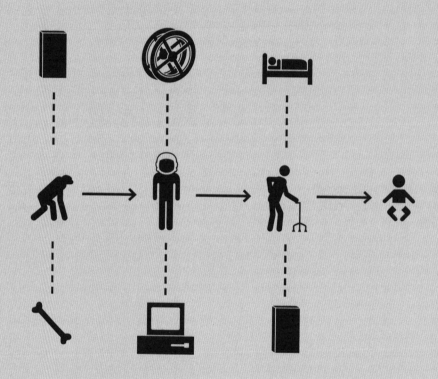

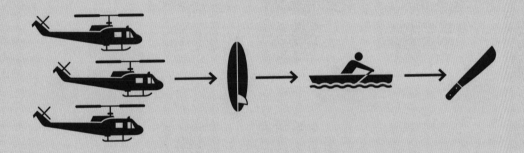

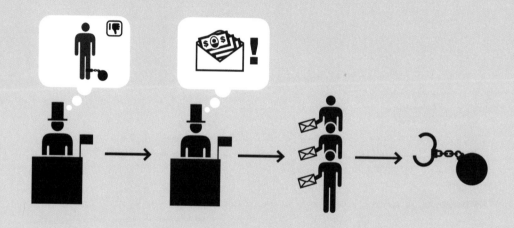

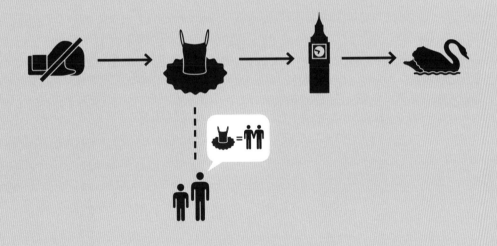

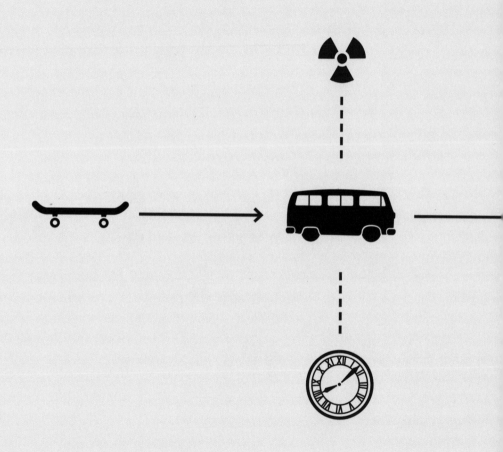

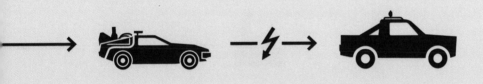

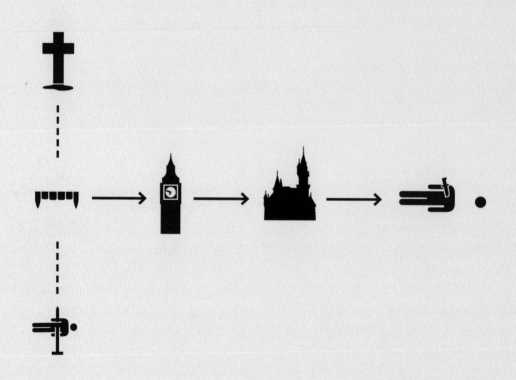

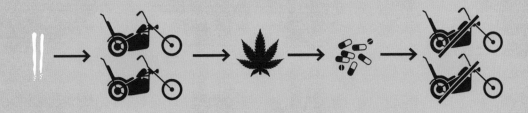

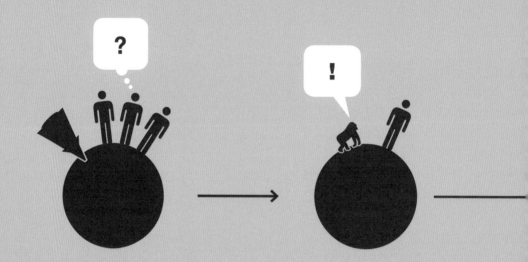

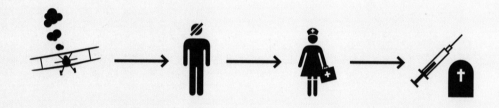

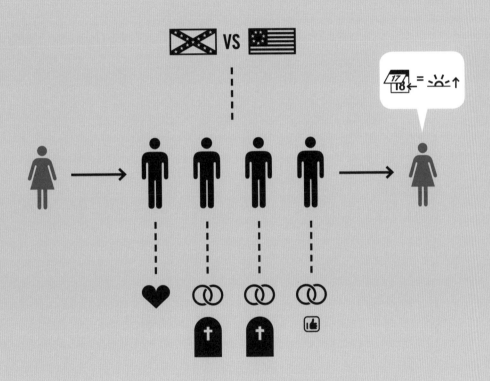

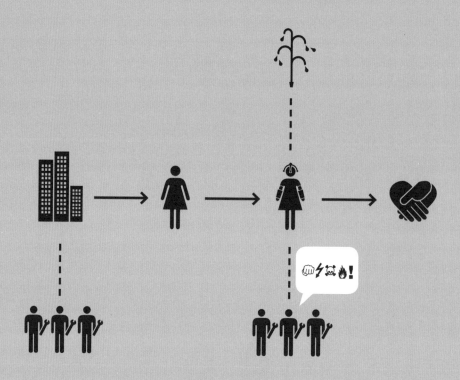

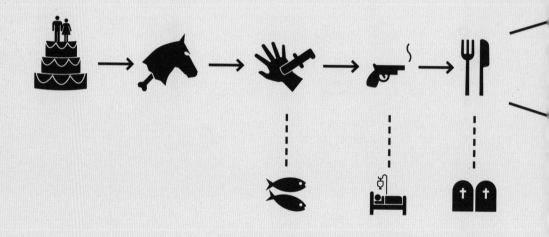

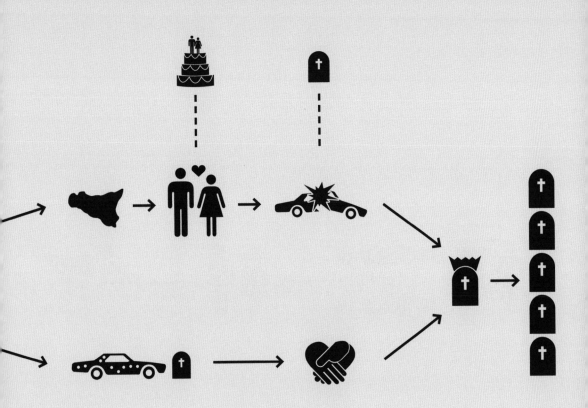

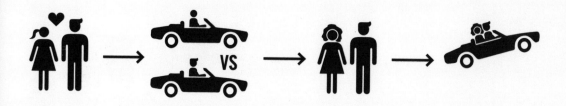

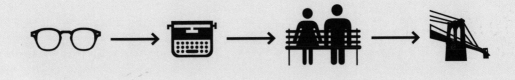

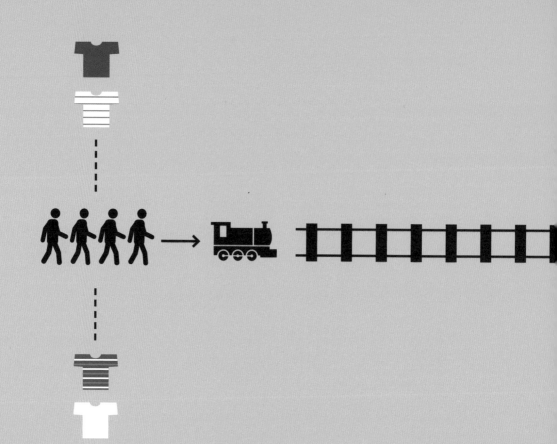

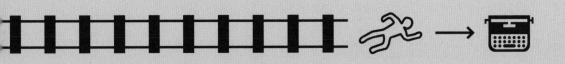

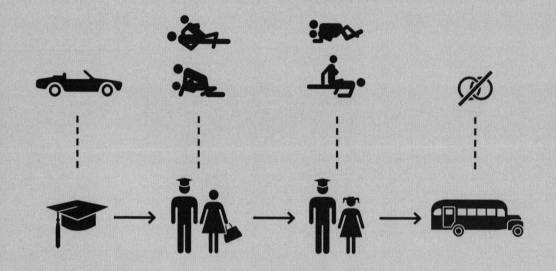

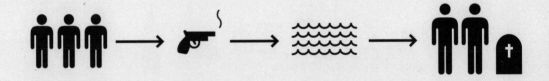

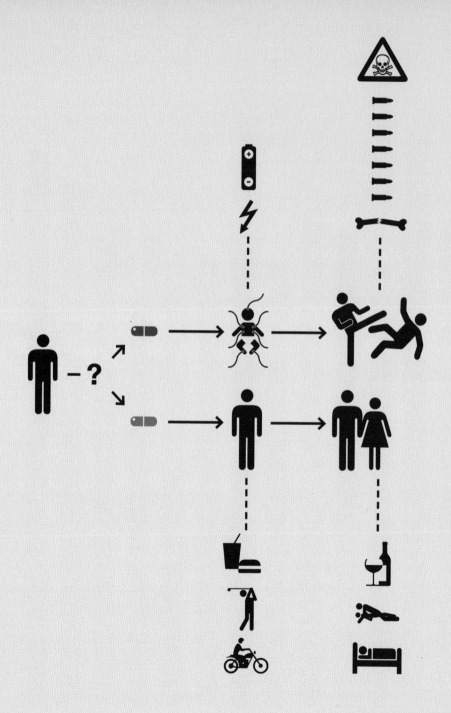

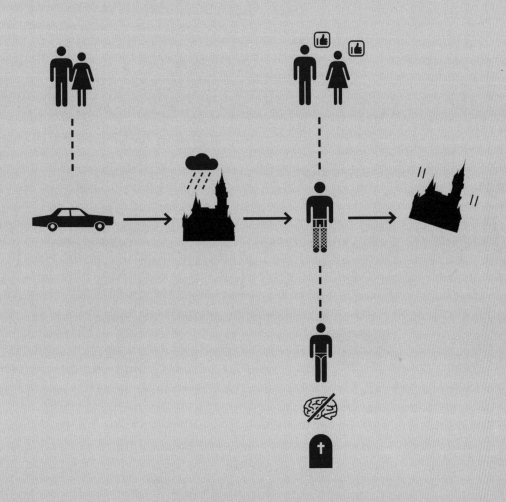

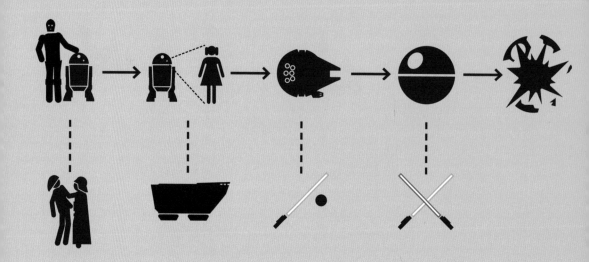

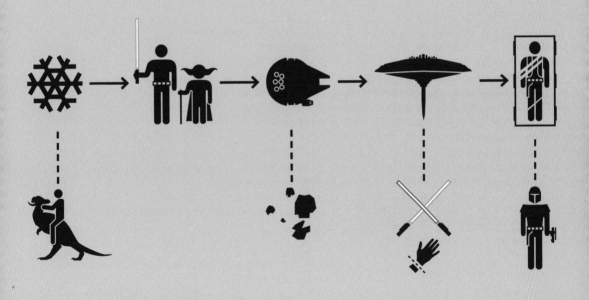

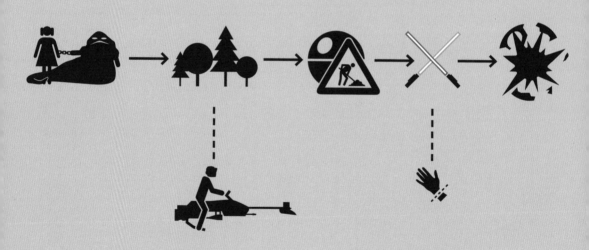

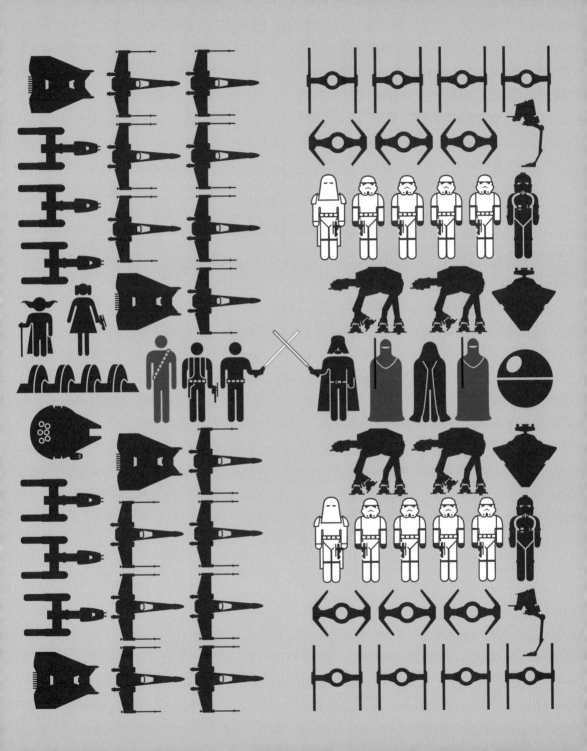

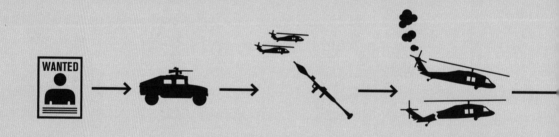

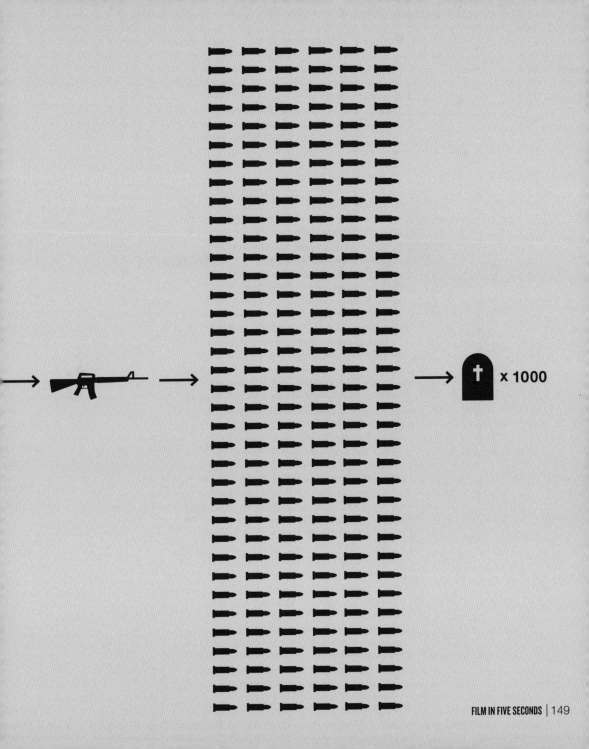

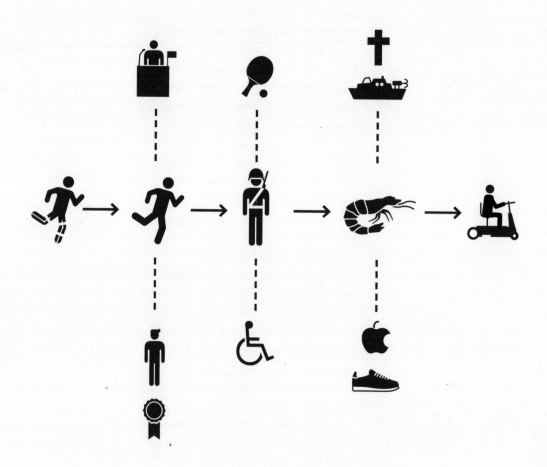

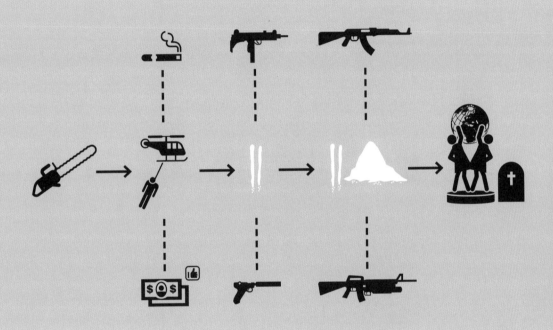

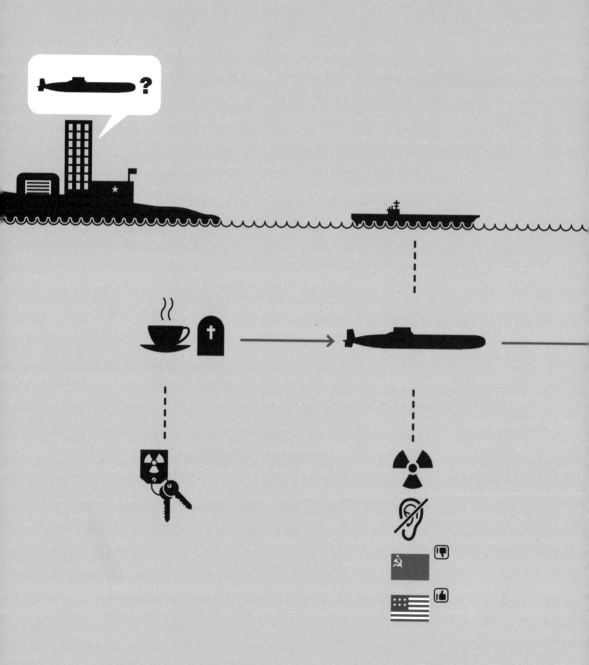

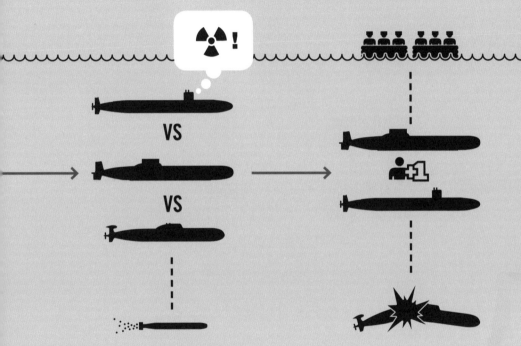
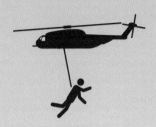

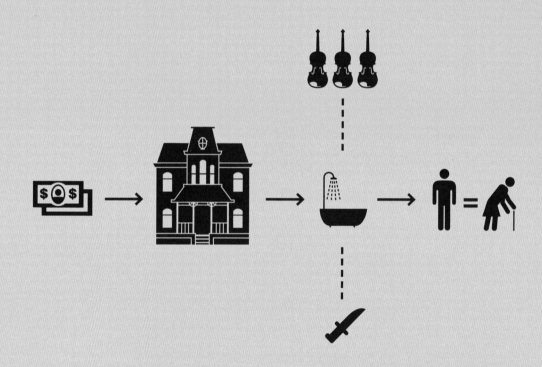

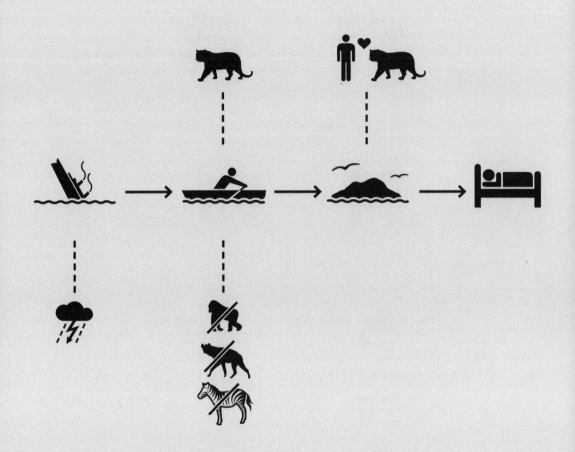

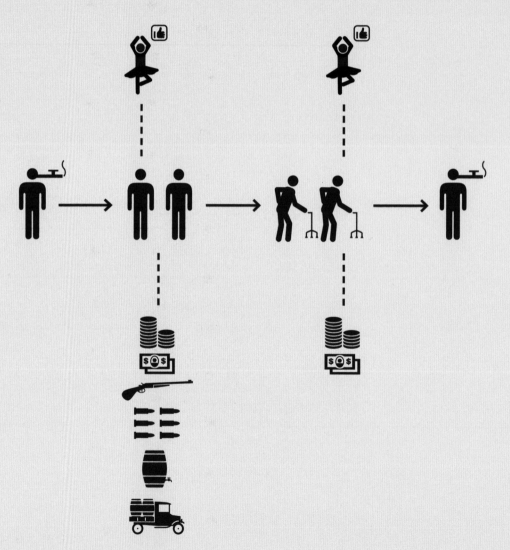

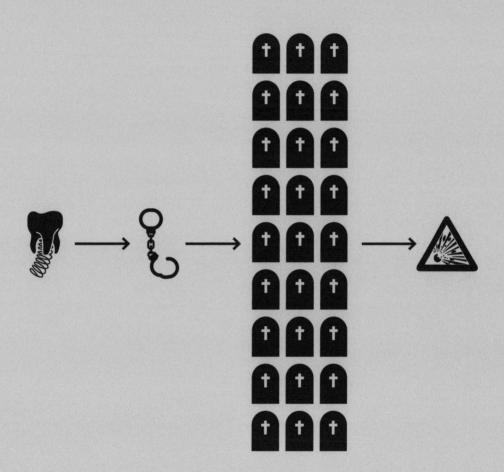

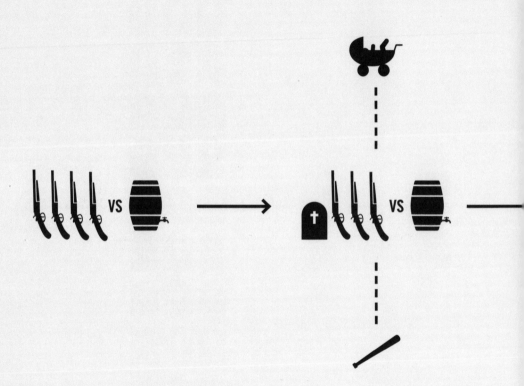

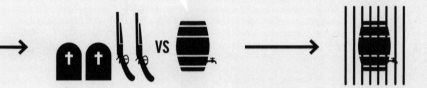

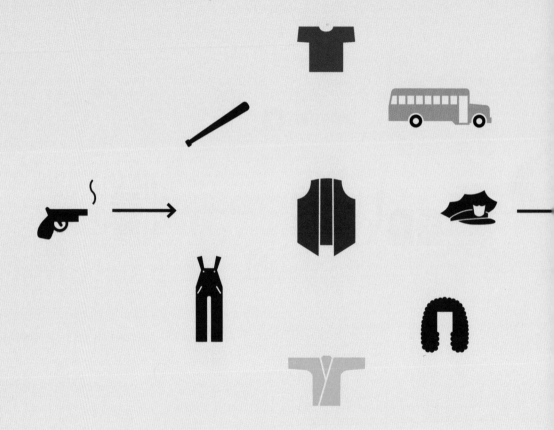

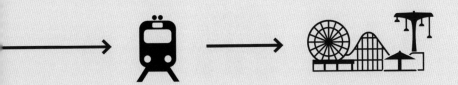

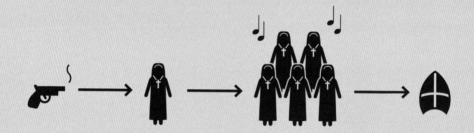

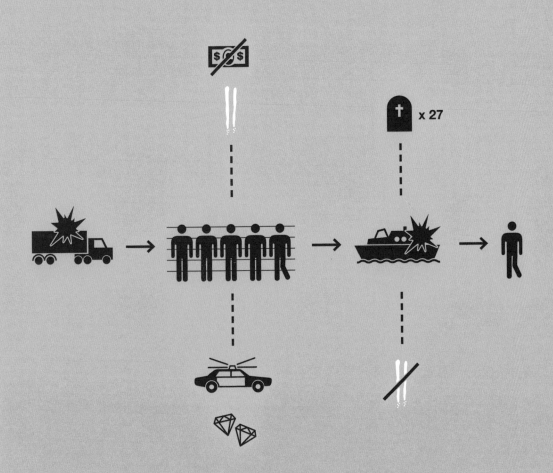

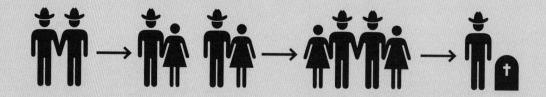

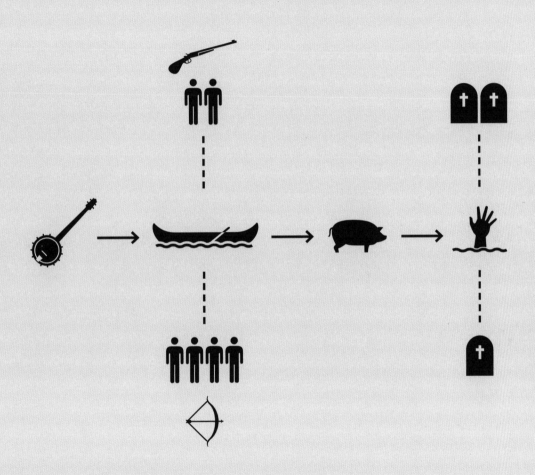

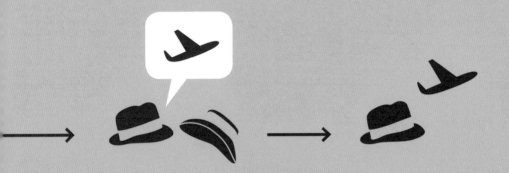

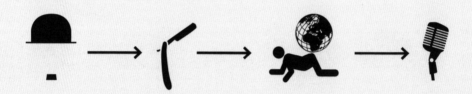

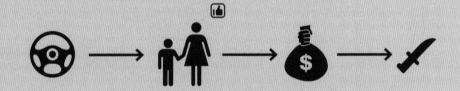

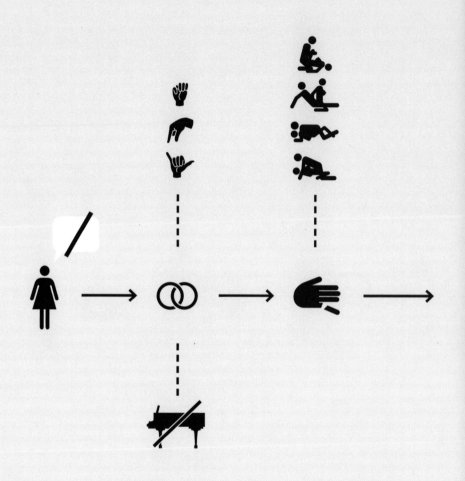

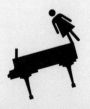

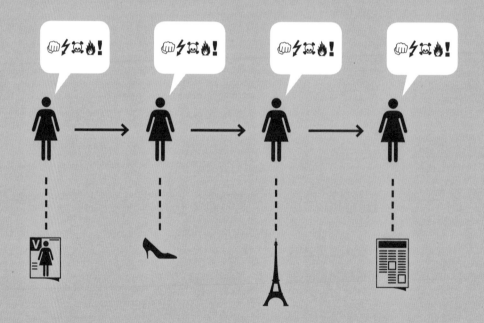

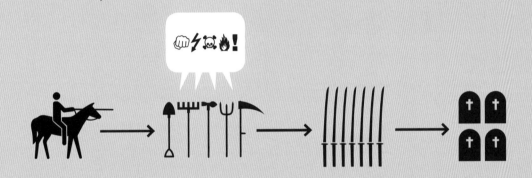

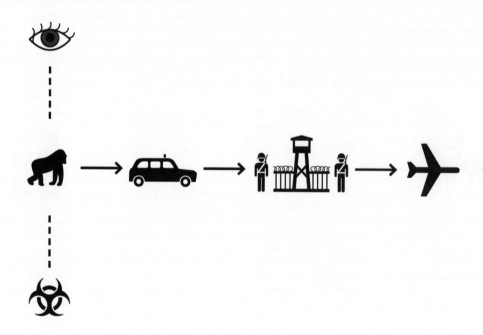

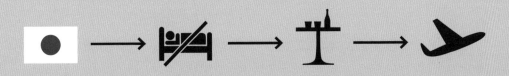

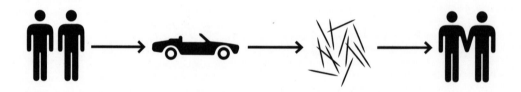

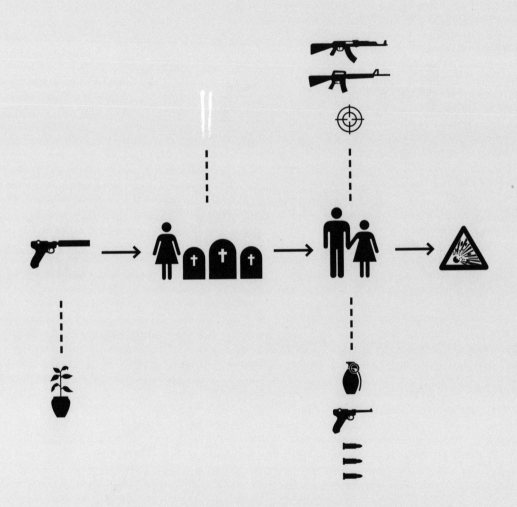

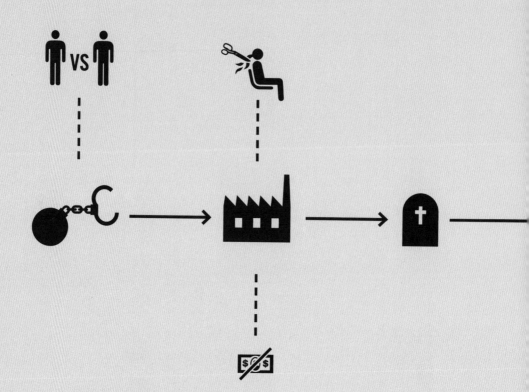

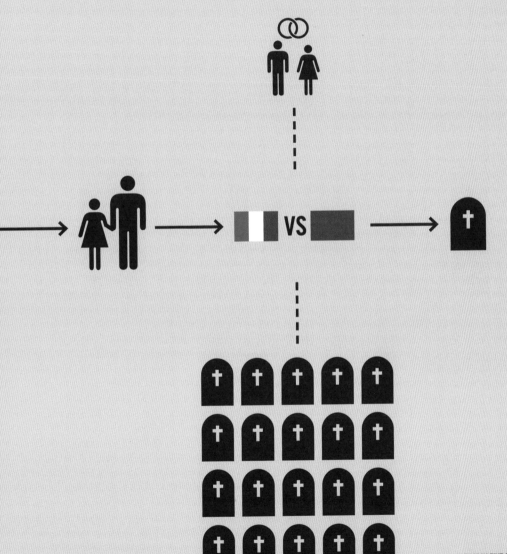

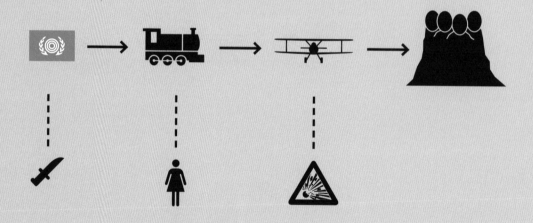

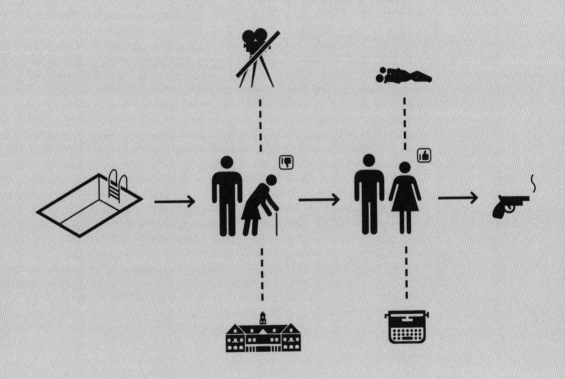

DIRECTOR'S KIT

Do you want to play out the plot of your favourite movie? Or would you prefer to make up a new one: your own personal masterpiece? No problem! Here are three practical kits to help you create stories from some classic film genres. If you think nothing's more fun than imagining the end of humanity, or at the very least spilling buckets of blood in great big battles, make a war movie! Play out the struggle for power over the Earth – or over who has to pay that big dry cleaning bill. None of it's real, anyway, not even the dead people. Plus, the good guys always win! If you've always had a soft spot for Mafia movies, amuse yourself with crime bosses, threats, suitcases full of money, drugs, explosions, insults, horses' heads, baseball bats, corrupt policemen and more. And remember to add at least one death every ten minutes (the minimum allowed by the World Gangsters' Association). Finally, for sentimental types, there's the romantic comedy kit. Begin at the end: he and she always end up realising they love each other (other combinations of sexes are possible but tend not to be so big at the box office). She must be impossibly beautiful, while he can range from reasonably handsome to incredibly handsome to French.

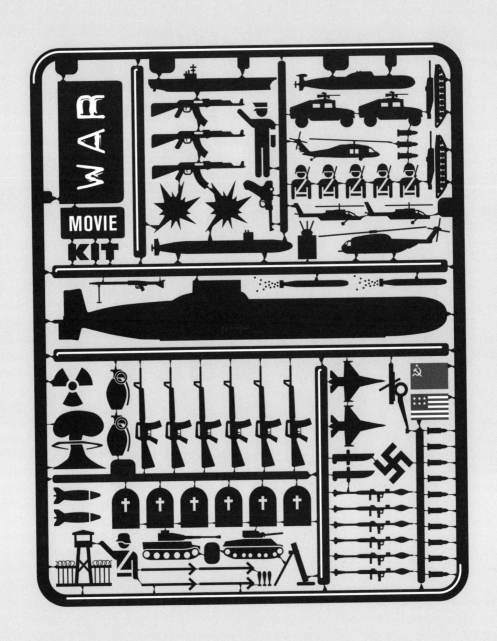

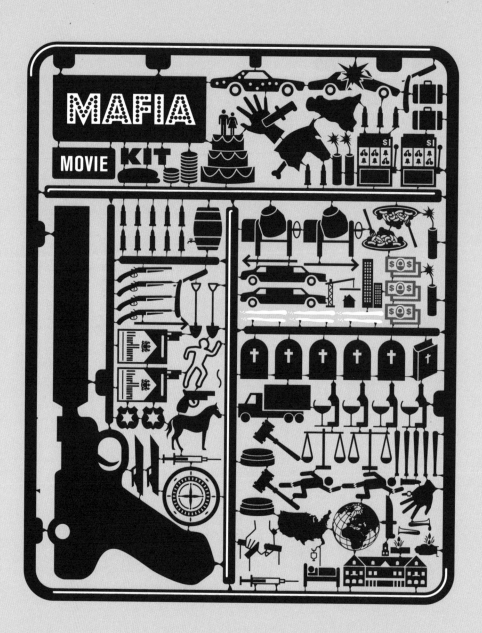

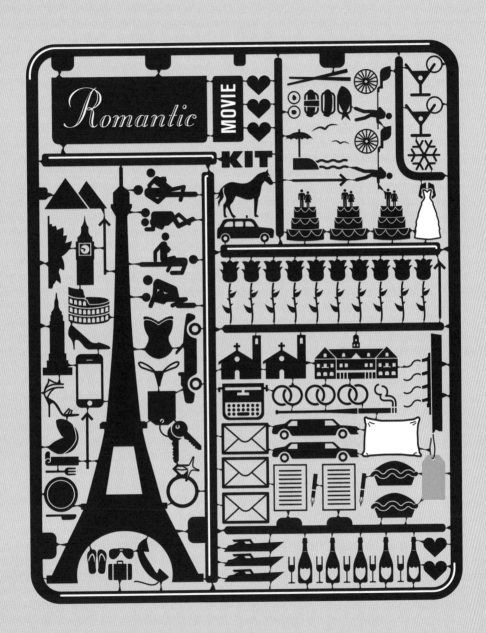

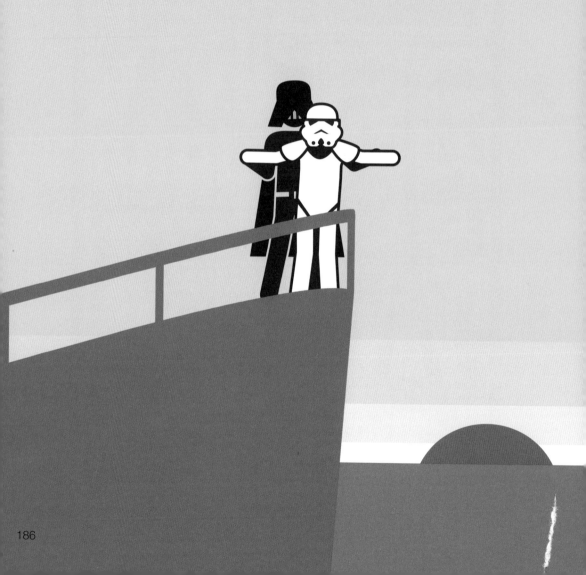

THANKS

Everything made at H-57 is a product of the whole team, so thank you to all the players who took to the field with us. In particular, Anna Barisani who helped us put this book together every day, providing ideas, drawings, laughter and a few curses. Thanks Annie, and good work. Also fundamental were Sabrina Gregorio and Marco Dalbesio, incomparable friends and veterans of many adventures, and all-round charming human beings. Thanks also to Jessica Ardizzone, Matteo Inchingolo and Stefano Agabio: all three are young, cute, talented and good table football players (more or less). A hug, at the end of a long but fun job, goes to Jenny Heller, Ione Walder, Ben Brock and Nick Clark at Quercus Books, for wanting this book to happen as much as we did. One day we will celebrate by going to the movies together. You can pick the film. Praise and gratitude also go to Will Francis, Rebecca Folland, Kirsty Gordon, Jessie Botterill and everyone else at Janklow & Nesbit for their constant and loving support. It all started with you. Thanks also, on behalf of all humanity, to Auguste and Louis Lumière. Finally, thanks to all the friends of Shortology and H-57 on Facebook, Twitter and all the other places where we meet and talk.

And now, go forth and multiply!

Until next time...

H-57 is a creative design and advertising studio based in Milan, Italy. Our name was inspired by the infamous Hangar 57, a legendary Russian Cold War base, the whereabouts and even the existence of which remain a mystery, but which was said to house horrific weapons of mass destruction, a laboratory for crazy biological experiments and all kinds of secret and dangerous things.

In the beginning, living up to our name, H-57 achieved success producing provocative and menacing T-shirts. We then found our true calling working on everything from graphic design to advertising, typography to illustration, animation to packaging. Thus, the H-57 Creative Station was born.

Soon, we began to collaborate with big agencies and international clients, including Coca-Cola, Sony Music, Condé Nast and Lucasfilm, for whom we produced a series of typographic posters inspired by *Star Wars*, which were sold for charity and the proceeds donated to Make-A-Wish Italy.

The roots of this book were a project to boil down moments of great historical, artistic or literary importance into their component parts, using graphics to tell a much bigger story. This method we now call 'Shortology'. The original result was six online 'stories' (Marie Antoinette, Hitler, Michael Jackson, Jesus, Julius Caesar and Napoleon), which quickly went viral. They came to the attention of a literary agent in London, who proposed the stories be made into a book, which became *Life in Five Seconds*, the predecessor of this book (and one which we suggest that you buy as soon as possible). Luckily, people seemed to like the book so we created this second volume, *Film in Five Seconds*. Thank you for sharing it with us. We hope you had a short but rewarding read. And keep on watching movies: it's still the second most fun thing to do in a room with the lights off.

The H-57 crew includes the authors of this book, Matteo Civaschi and Gianmarco Milesi, plus Sabrina di Gregorio and Marco Dalbesio, ably supported by Anna Barisani, Jessica Ardizzone, Matteo Inchingolo and Stefano Agabio, a great, small group of young, talented graphic designers and art directors.

Matteo Civaschi

Matteo founded H-57 in 2004, together with Elena Borghi (who has since left), after 15 years working for big advertising agencies. Fond of music by Mozart and Van Halen, he is also a huge fan of science fiction films, from Ridley Scott's *Alien* to the world-famous, epic *Star Wars* saga by George Lucas. His three cats are his favourite assistants, especially during the nights when major projects come to life.

- - -

Gianmarco Milesi

In his early life, Gianmarco planned – in chronological order – to become: flute virtuoso, NBA player, guitarist and Egyptologist. That all went out of the window when he discovered copywriting, finding it to be a beautiful and entertaining job. After 12 years struggling along at large advertising agencies, he joined Matteo Civaschi at the helm of H-57. Upon retirement, he intends to become a flute virtuoso, NBA player, guitarist and Egyptologist.

- - -

The H-57 Team

AND NOW, THE ANSWERS...

Quercus Publishing Plc
55 Baker Street
7th Floor, South Block
London
WIU 8EW

First published in 2013

10 9 8 7 6 5 4 3 2 1

Copyright © 2013 H-57 S.r.l.

A catalogue record of this book is available from the British Library

ISBN 978 1 84866 296 4

Publishing Director: Jenny Heller
Editorial: Ione Walder, Ben Brock

Printed and bound in Portugal

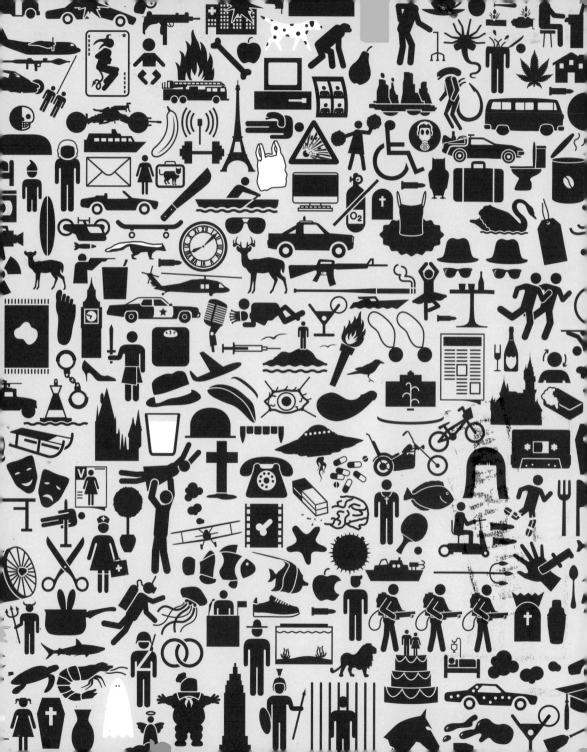